Whimsical Gardens

COLORING BOOK

ALEXANDRA COWELL

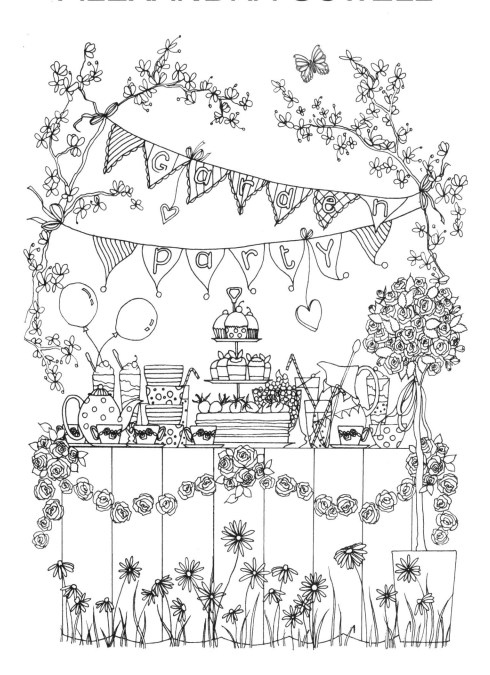

DOVER PUBLICATIONS, INC.
MINEOLA, NEW YORK

A heartwarming home with a bountiful garden welcomes you to this whimsical and imaginative book of designs. Gardens can turn any patch of ground into a delightful place, so take a stroll along a beautiful stone path to admire an archway of roses. Specially designed for the experienced colorist, the thirty-one detailed images included here feature sweet little birds perched on branches; a festive garden party complete with cupcakes; vibrant floral blooms; and even a serene lily pond with cattails. The pages in this book are unbacked so that you may use any media for coloring, and are perforated for easy removal.

Bibliographical Note
Whimsical Gardens Coloring Book is a new work, first published by Dover Publications, Inc., in 2015.

International Standard Book Number
ISBN-13: 978-0-486-79675-8
ISBN-10: 0-486-79675-2

Manufactured in the United States by RR Donnelley
79675215 2015
www.doverpublications.com

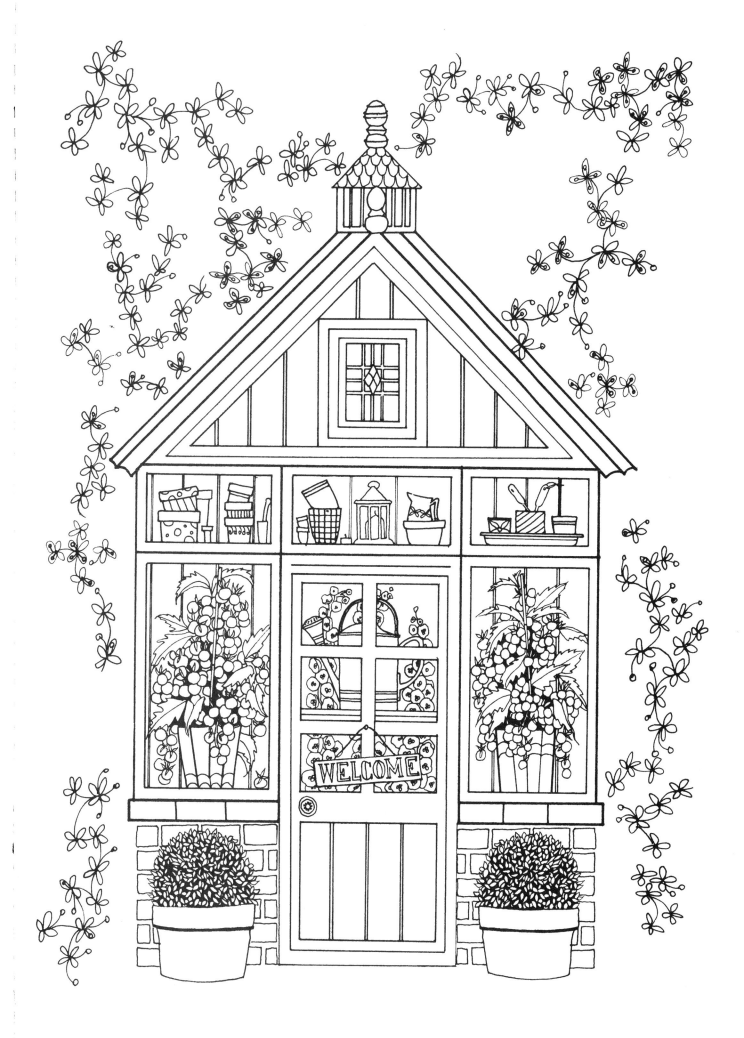

WELCOME

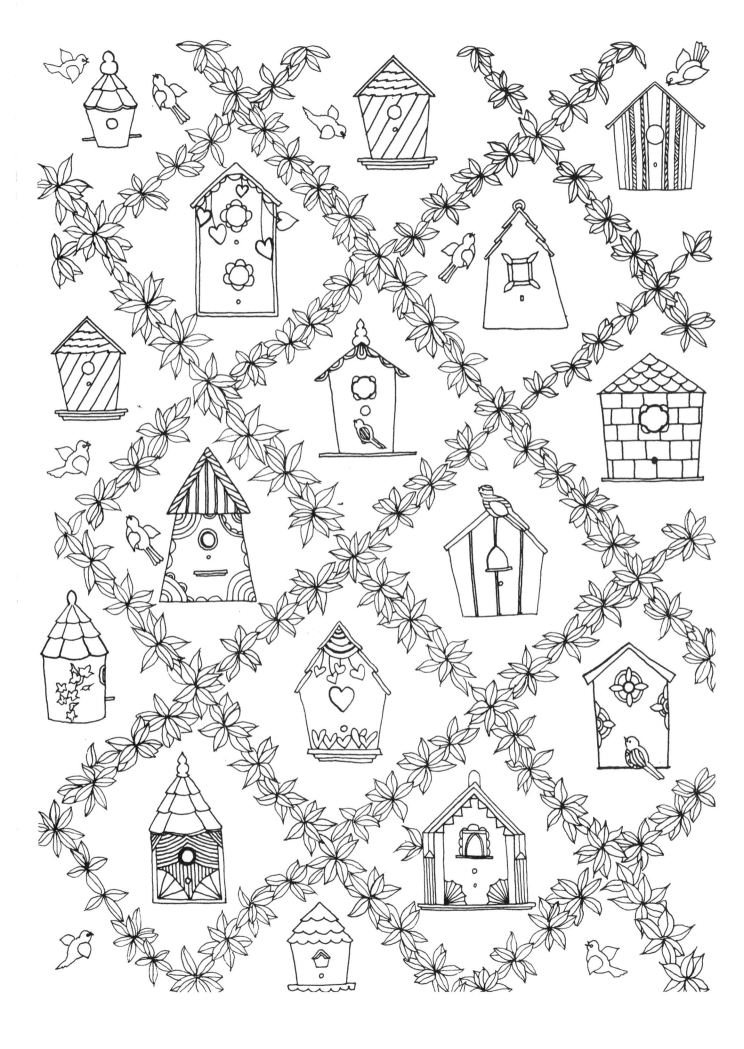

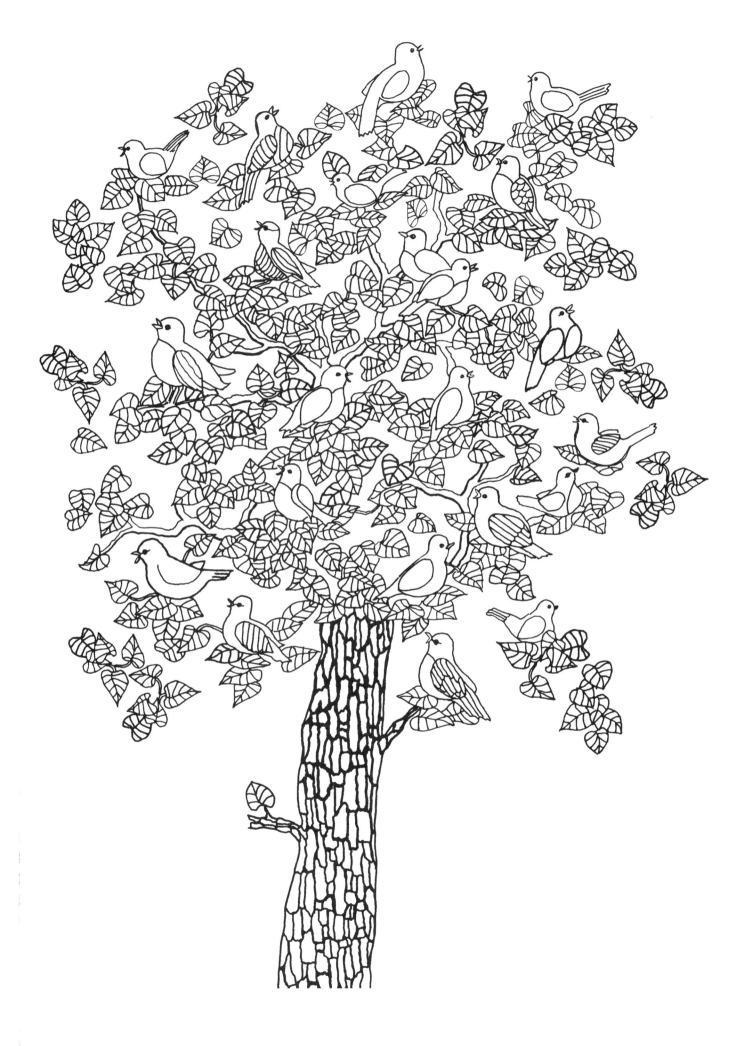

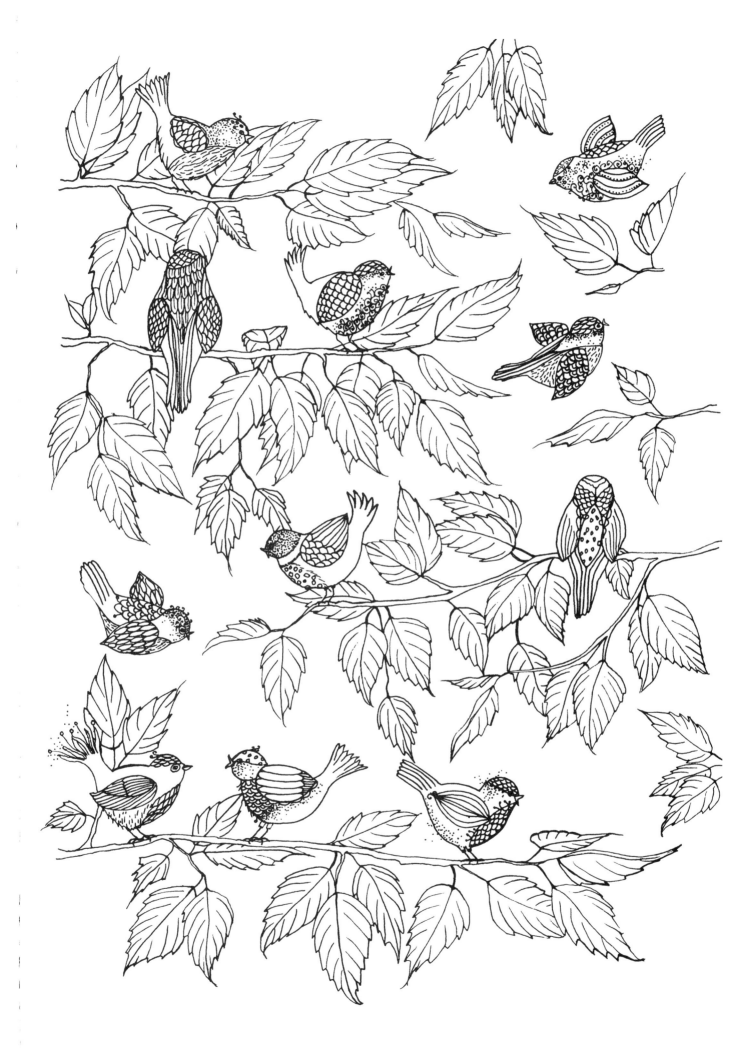

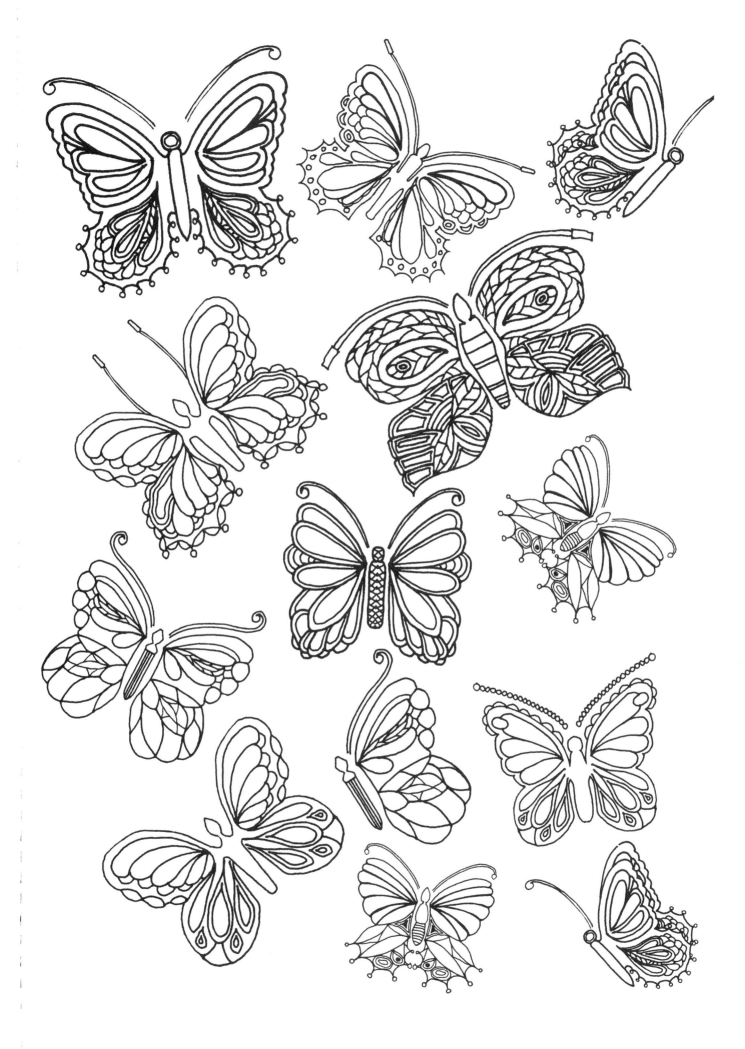

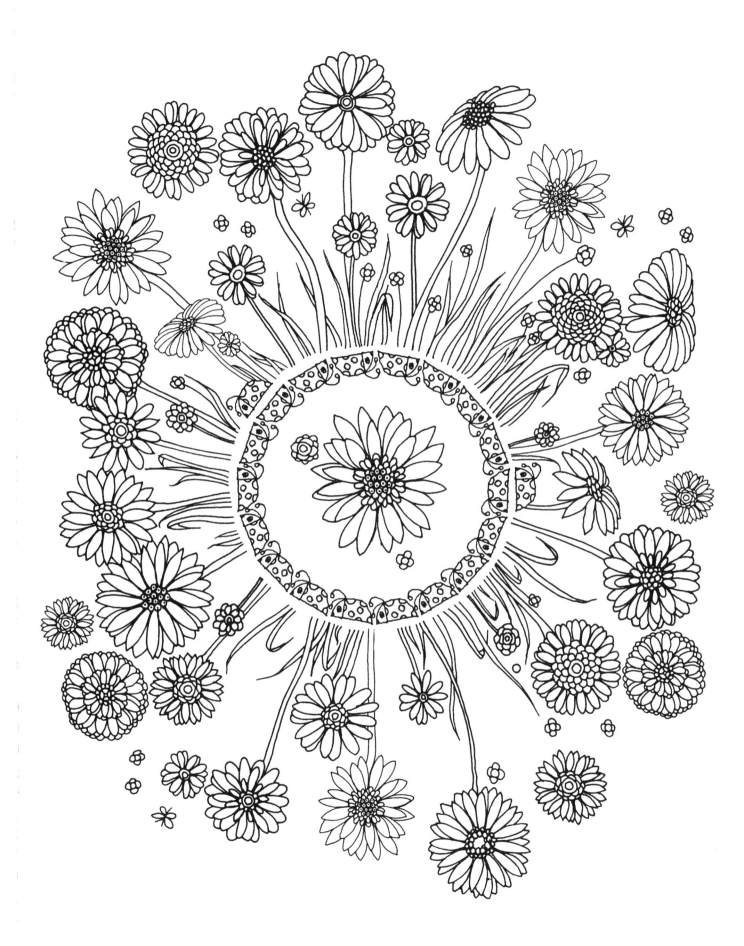

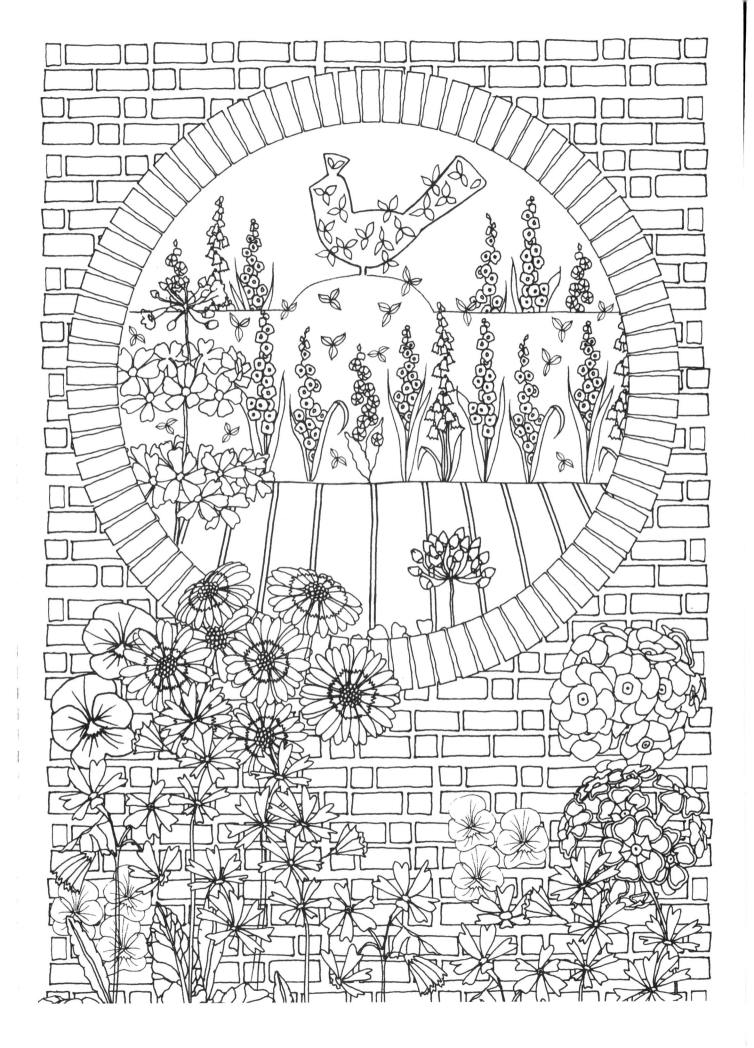

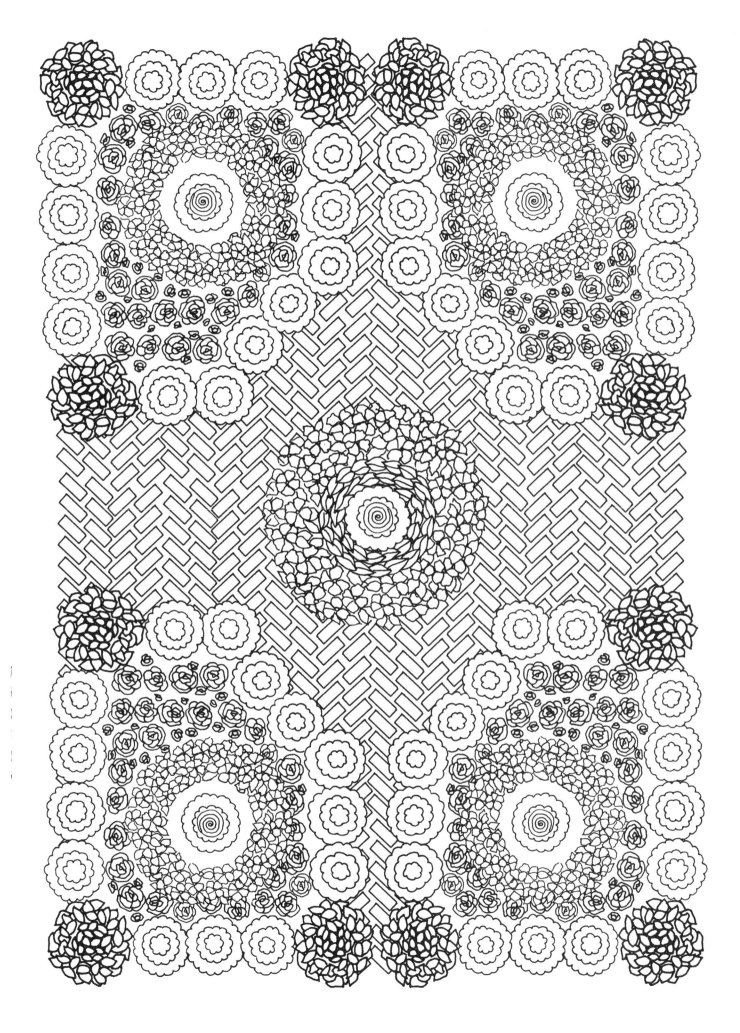

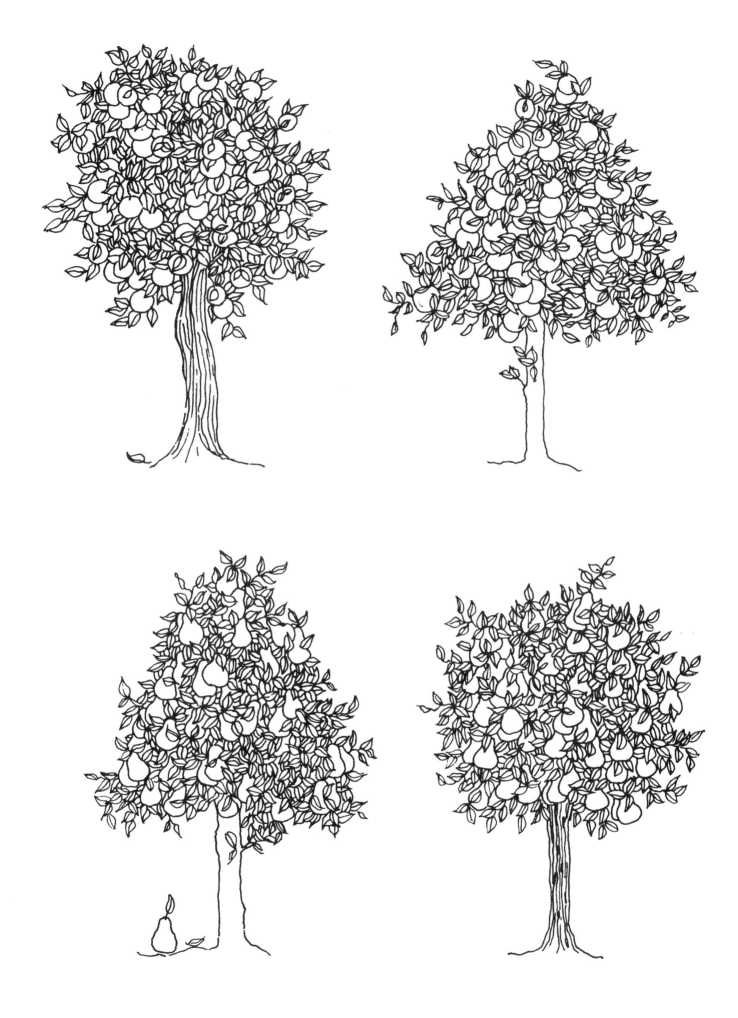

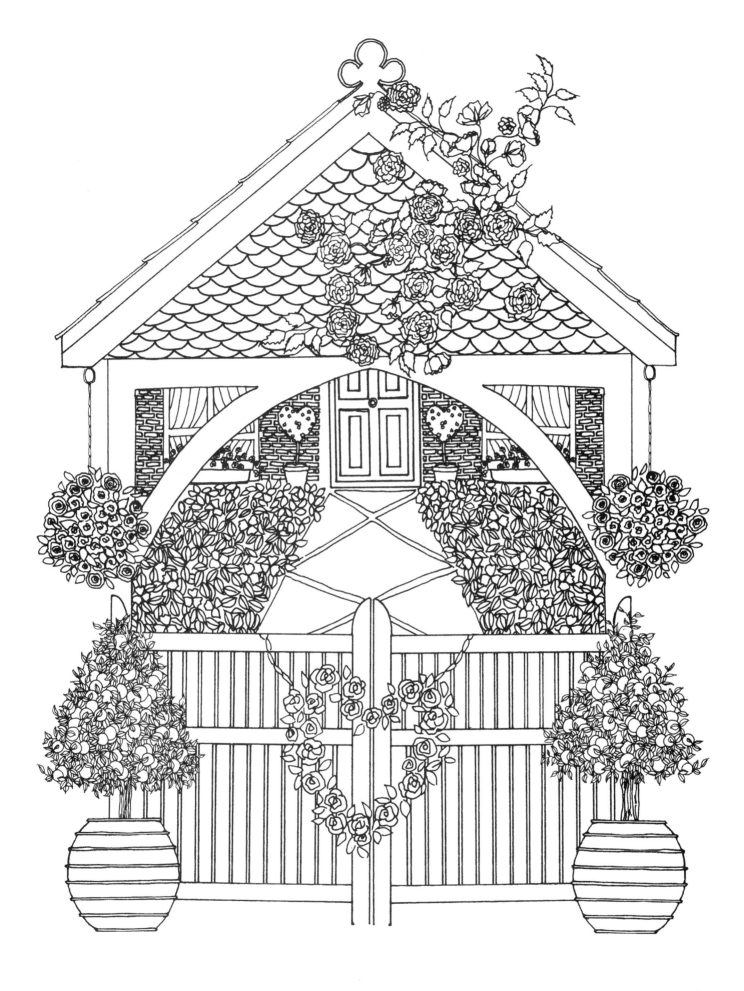

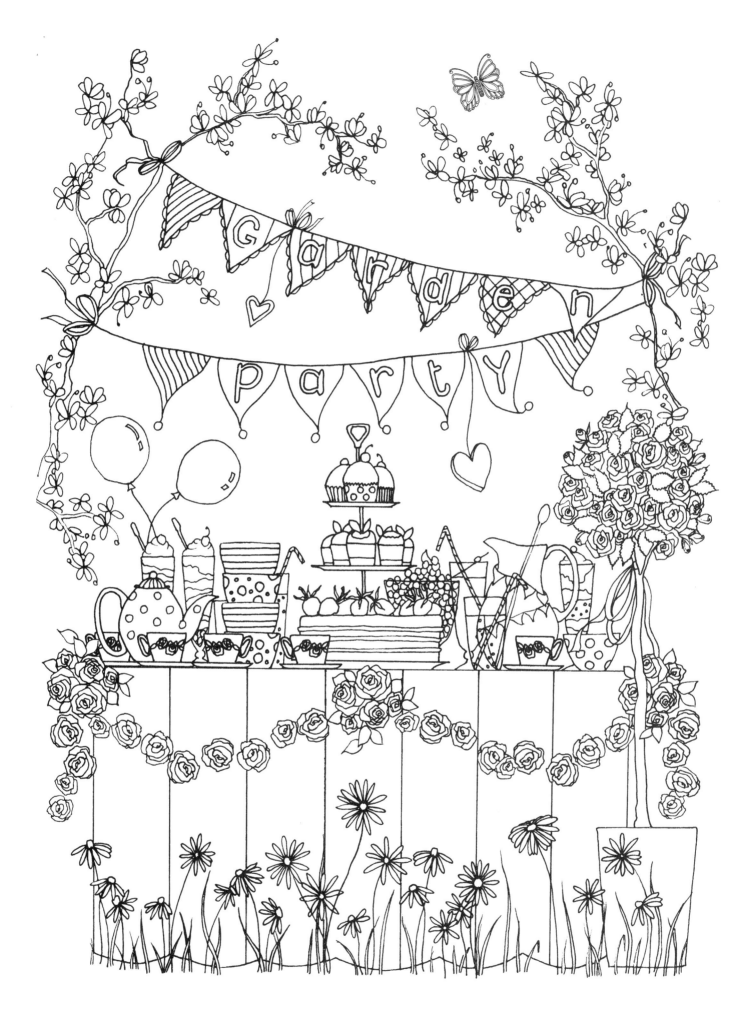

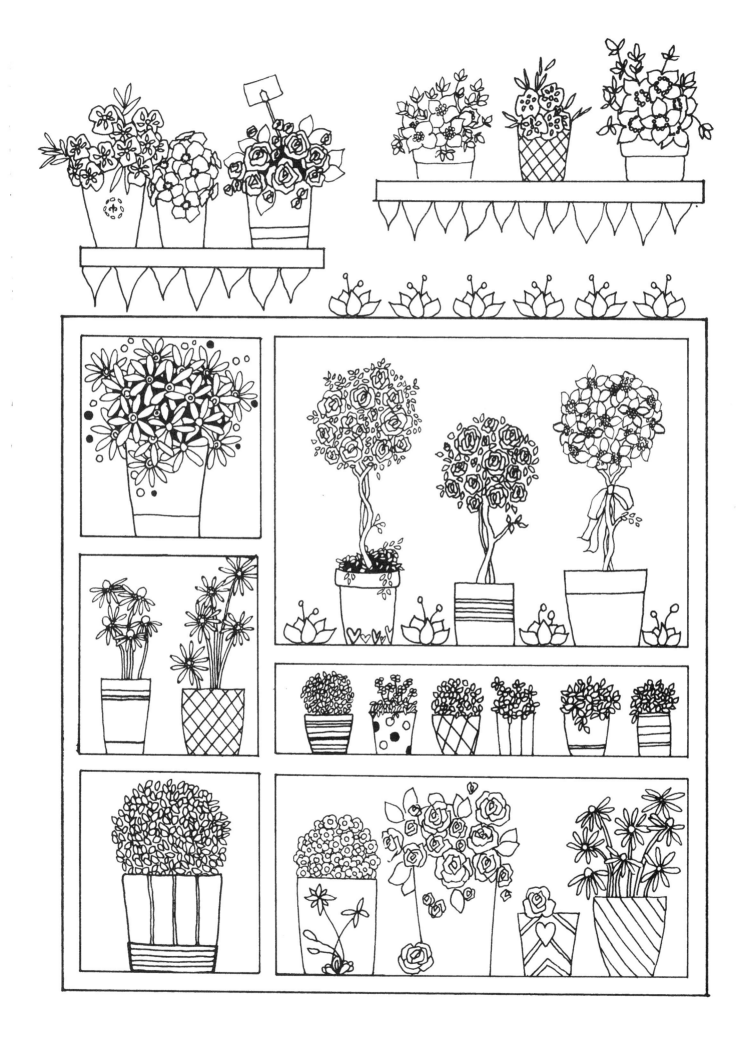

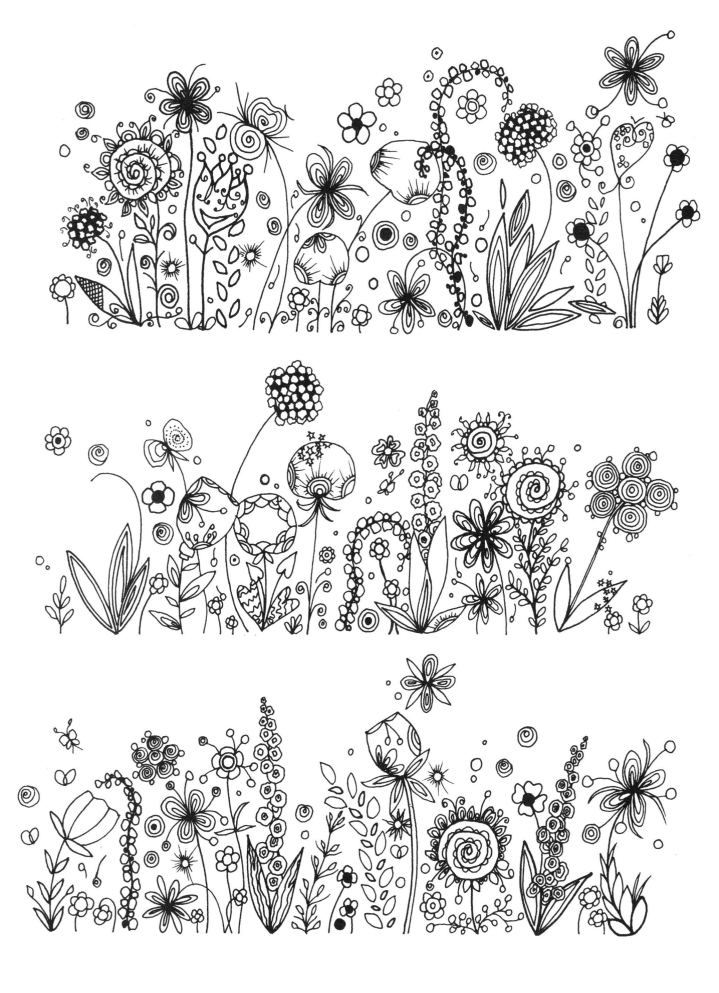

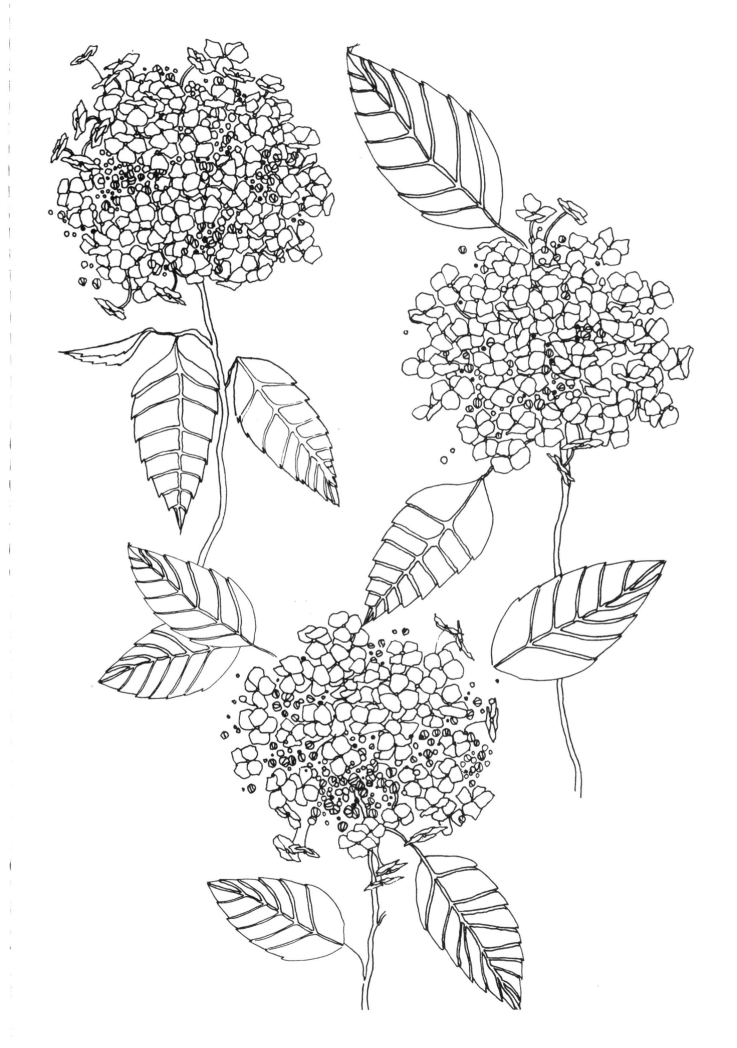

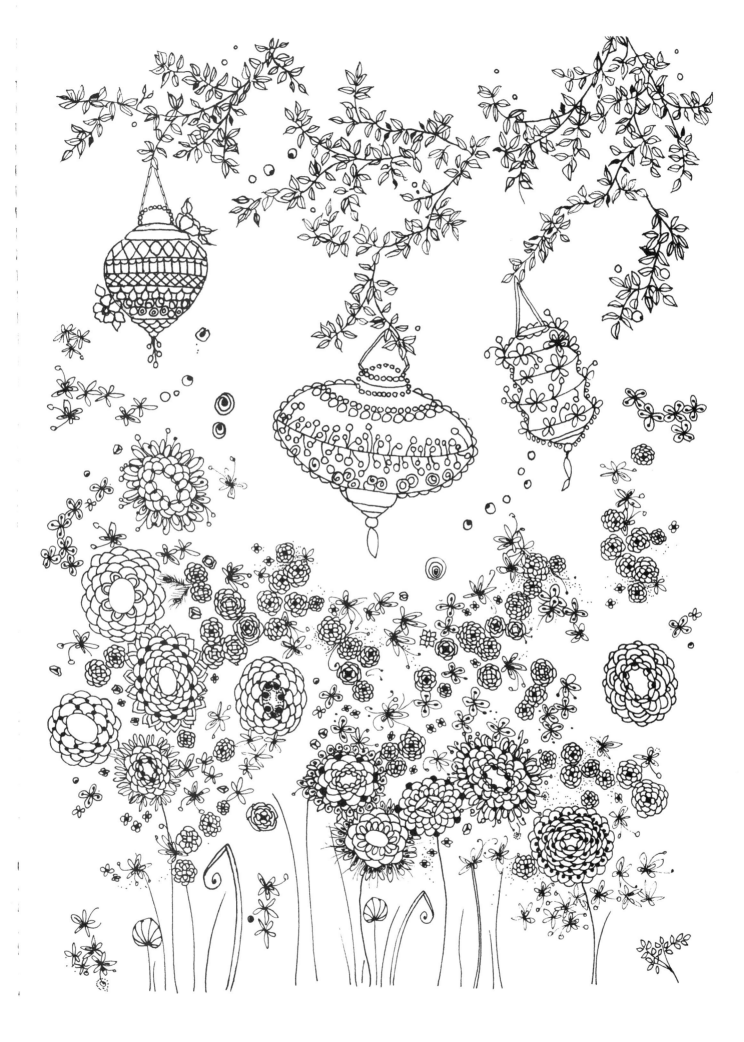

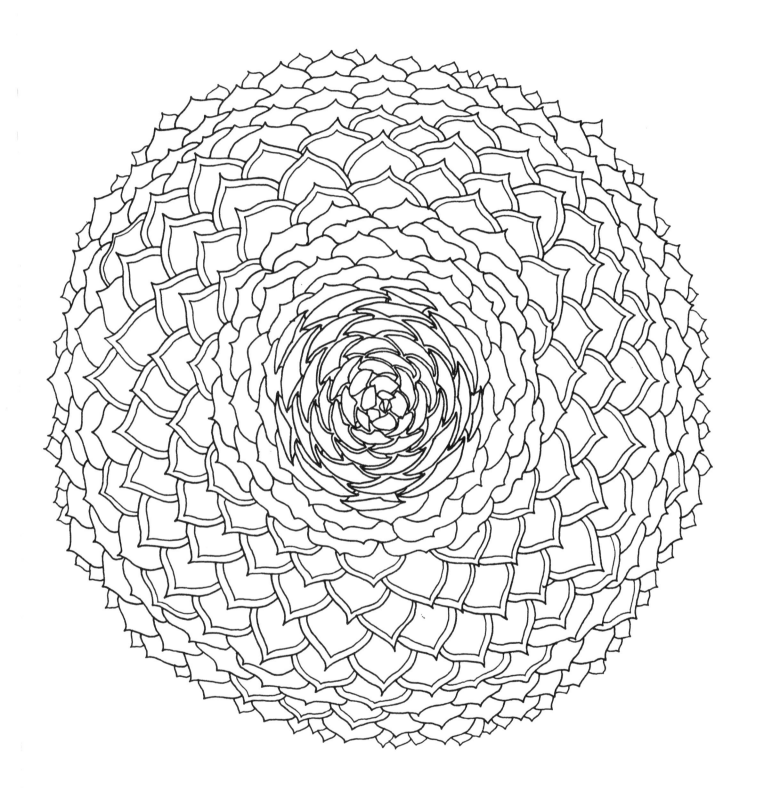

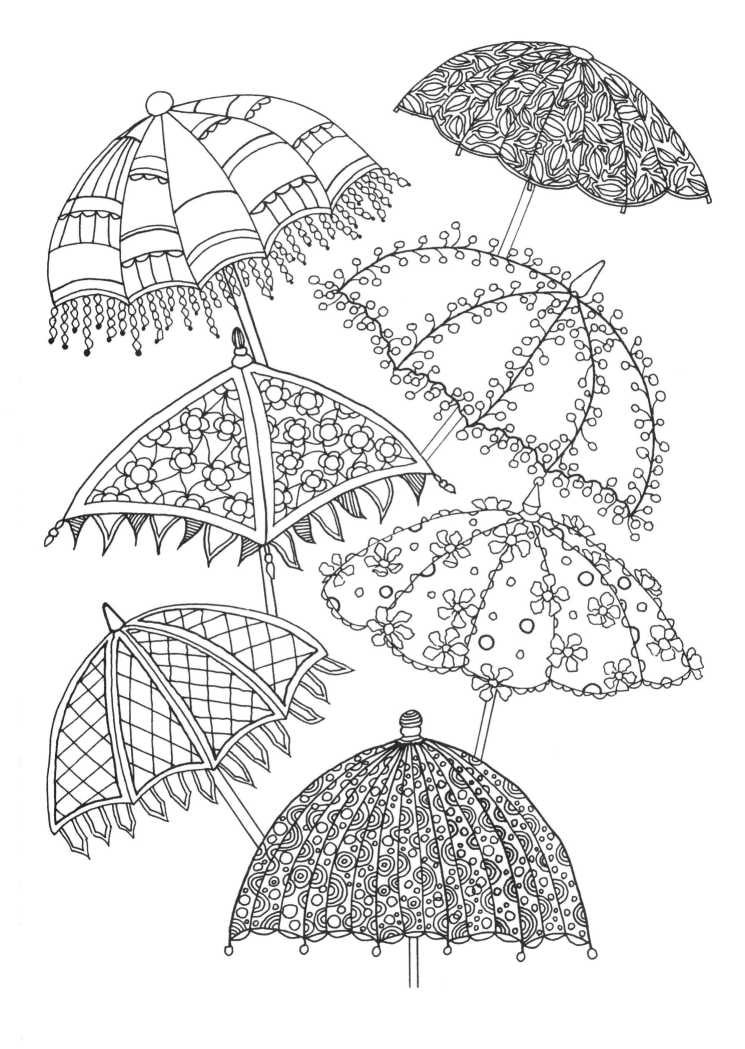

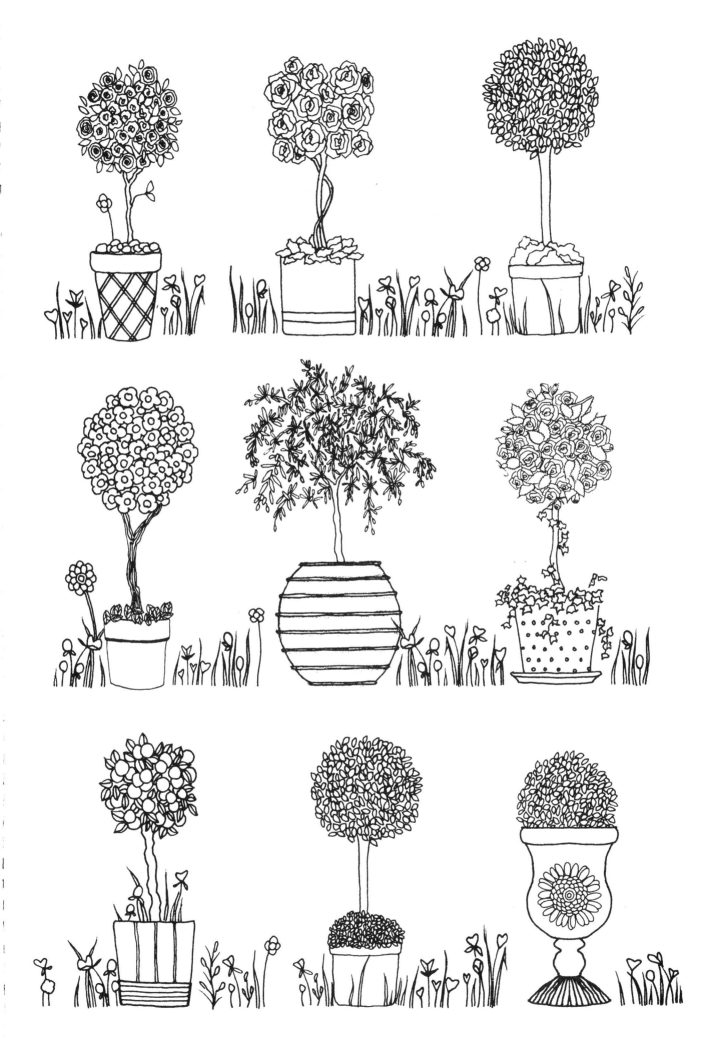

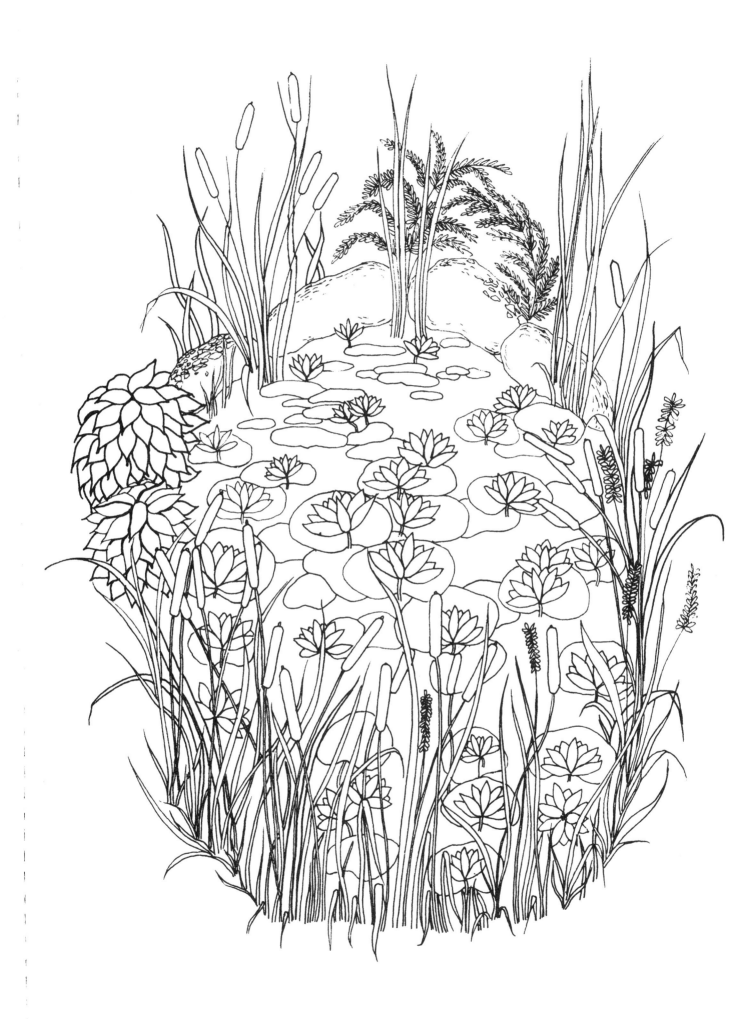

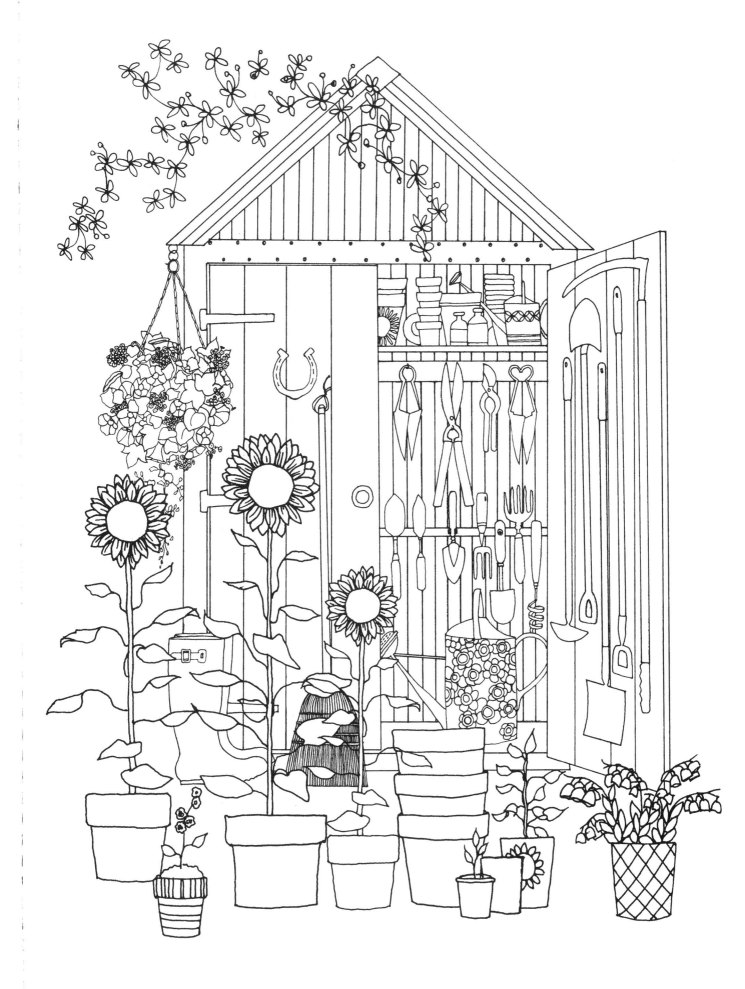

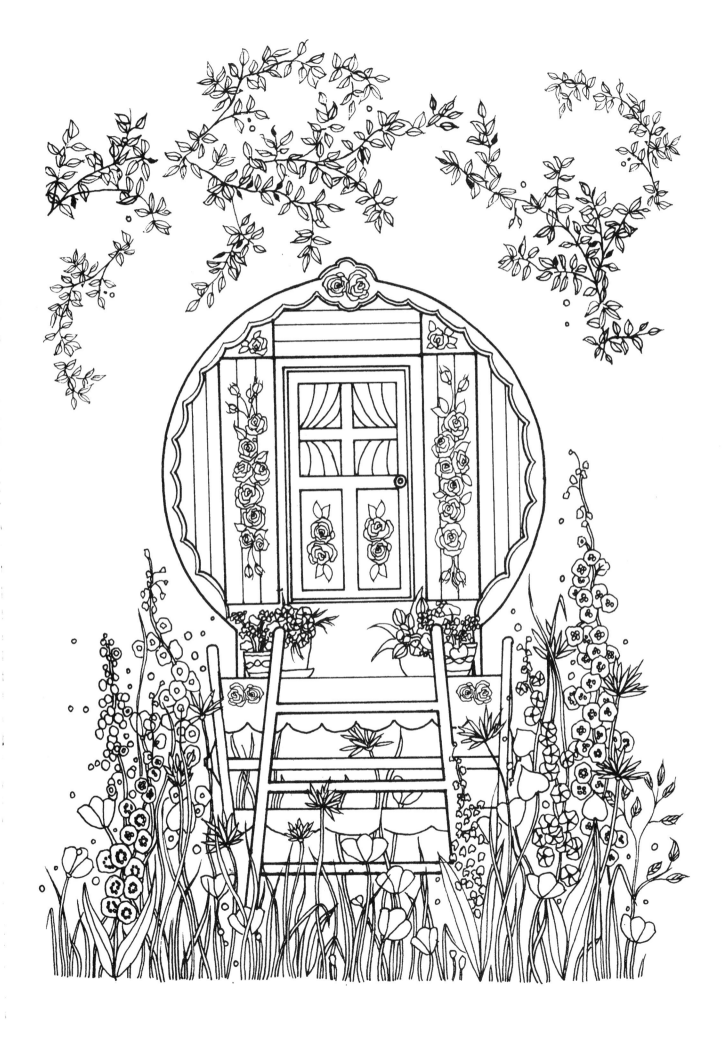

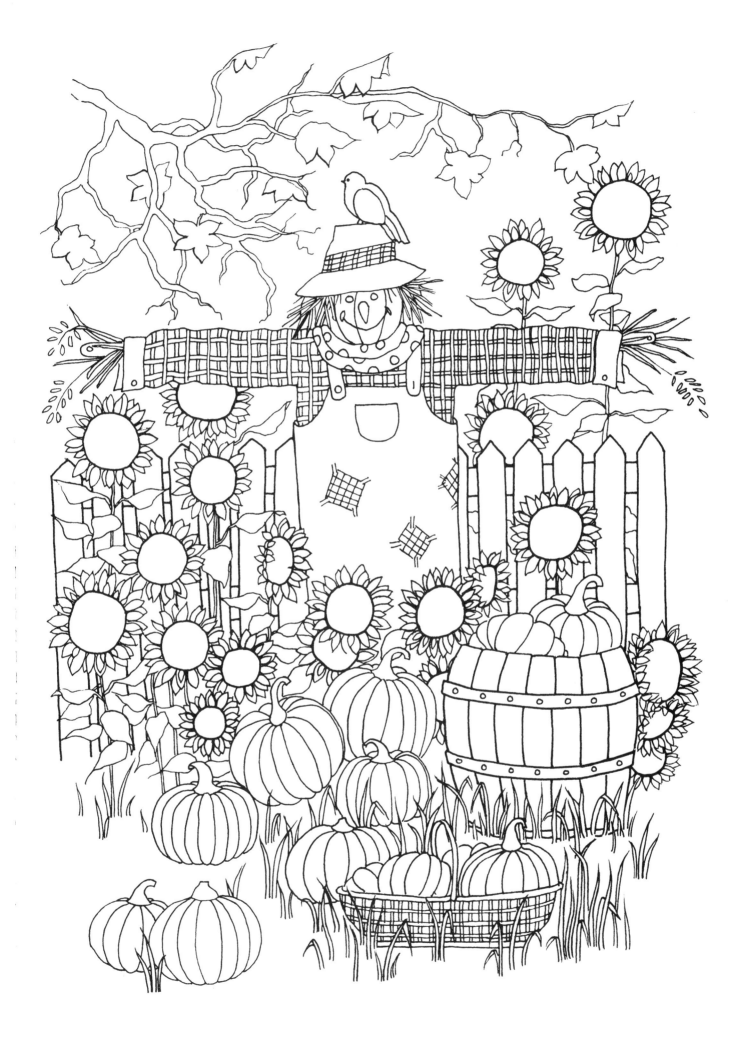

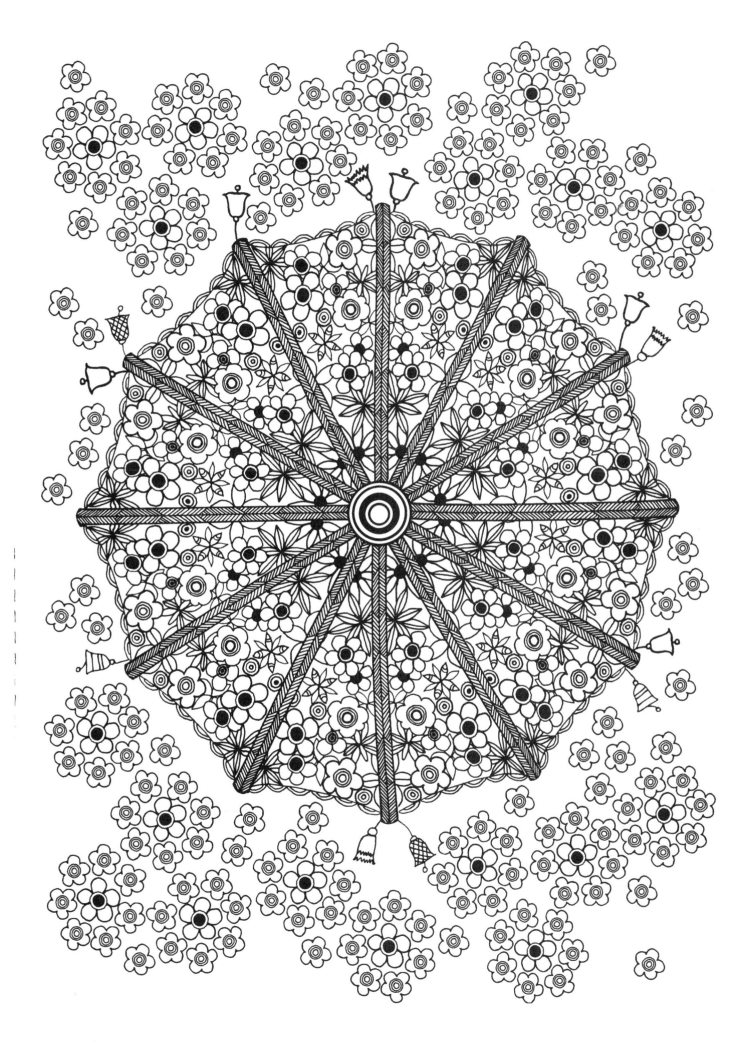

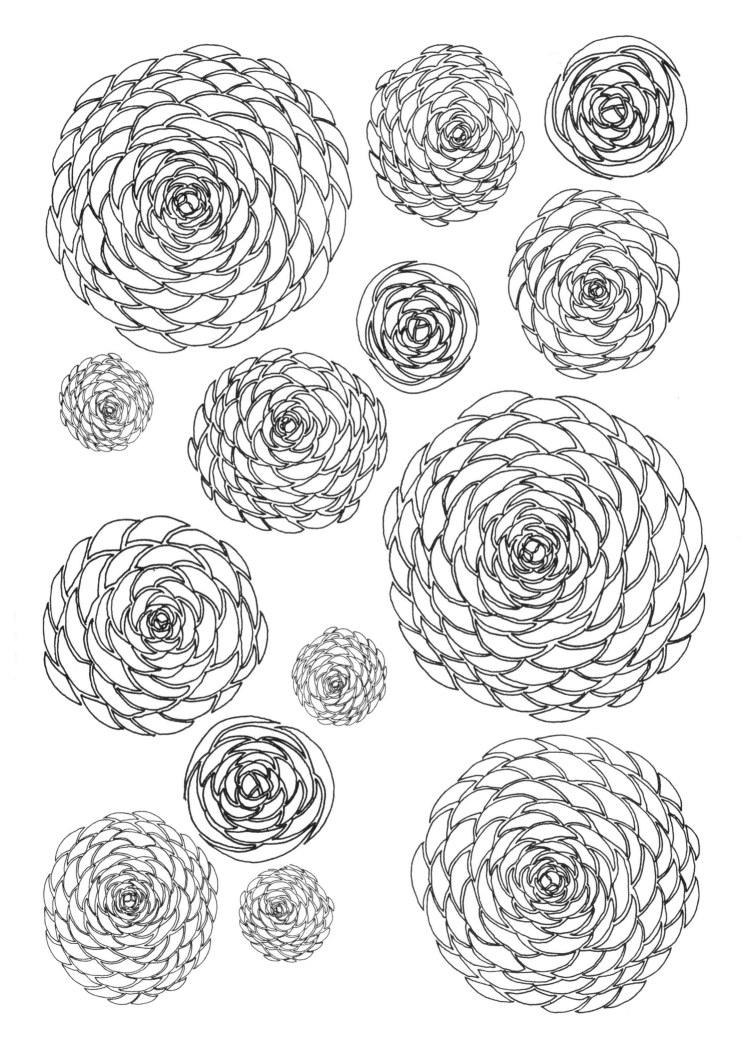

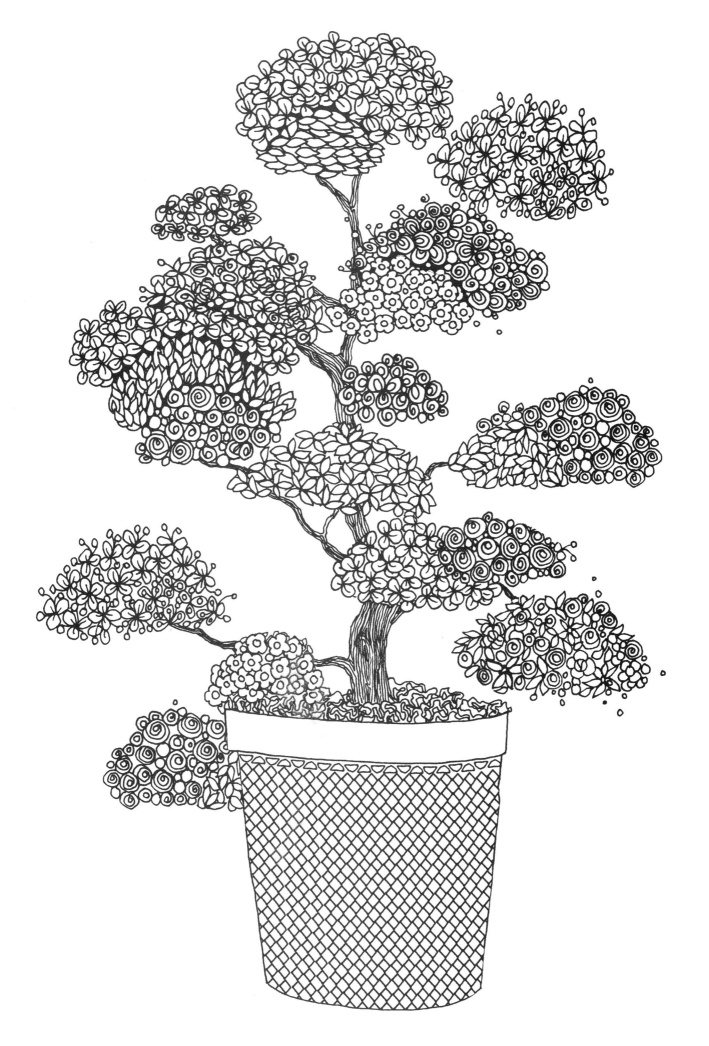

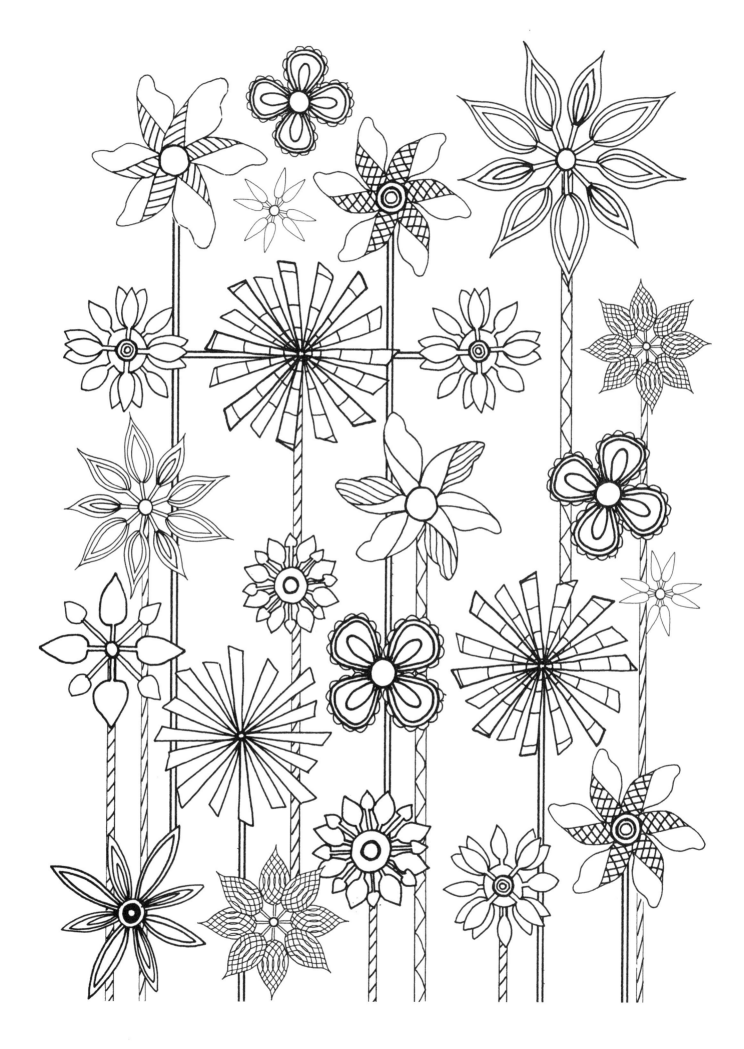

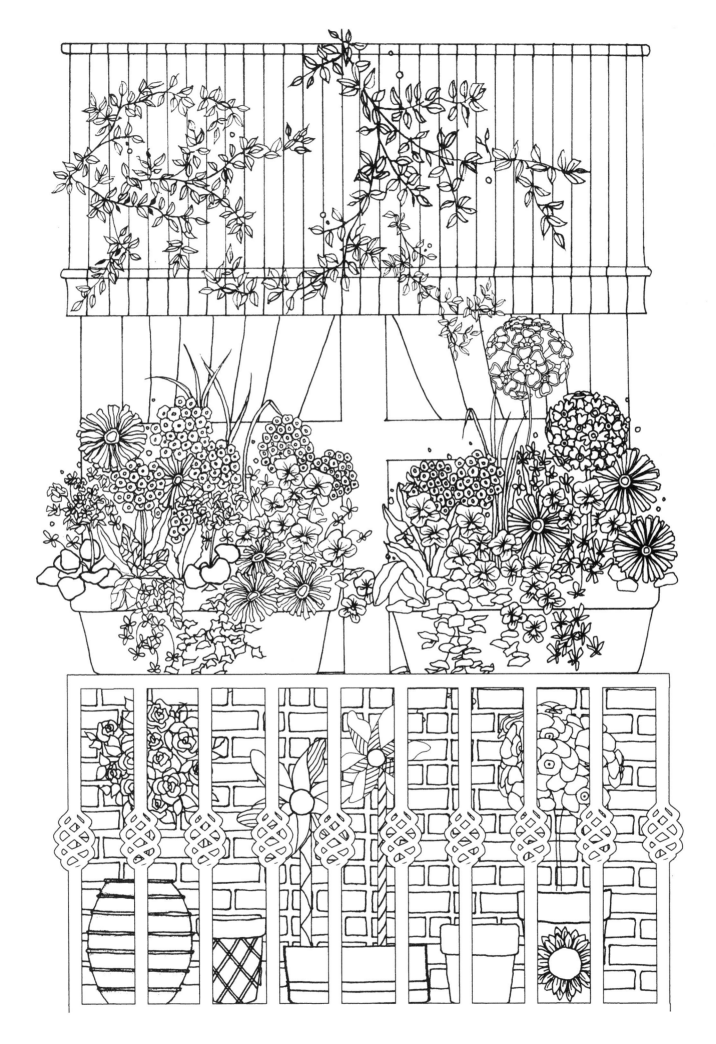

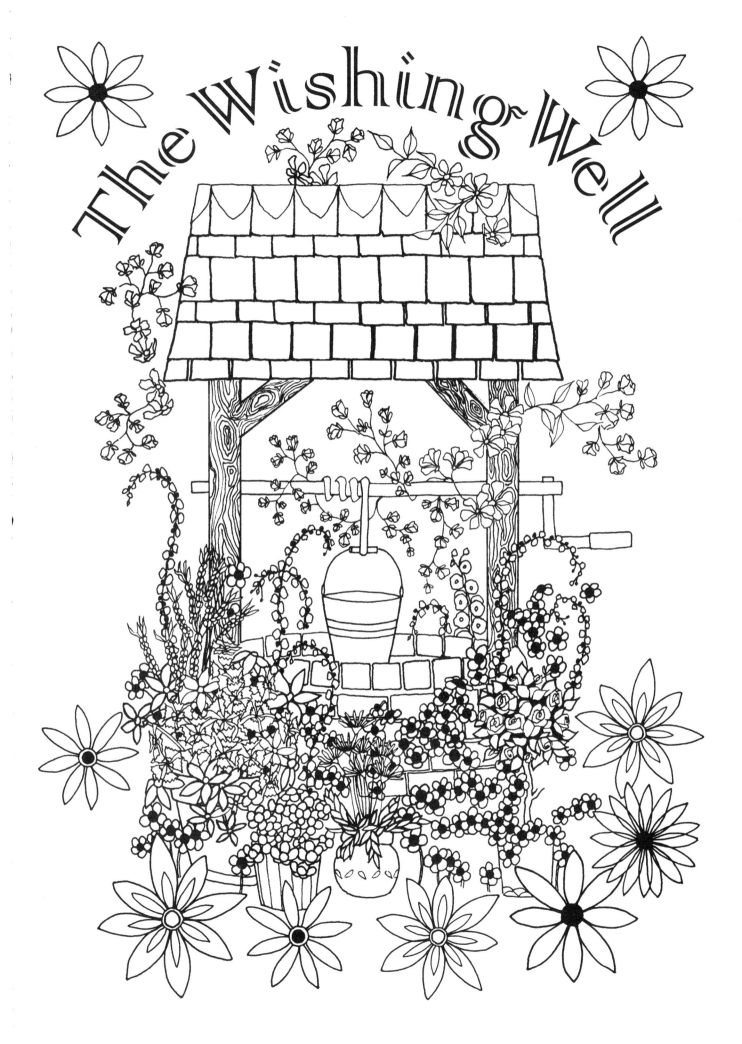